SILK POEMS

NIGHTBOAT BOOKS, NEW YORK

JEN BERVIN

SILK POEMS

© 2017 JEN BERVIN

ALL RIGHTS RESERVED

PRINTED IN THE UNITED STATES

ISBN 978-1-937658-72-4

DESIGN BY QUEMADURA

TEXT SET IN INTERSTATE AND MRS. EAVES

COVER AND INTERIOR ART BY JEN BERVIN

CATALOGING-IN-PUBLICATION DATA IS AVAILABLE

FROM THE LIBRARY OF CONGRESS

DISTRIBUTED BY UNIVERSITY PRESS OF NEW ENGLAND

ONE COURT STREET

LEBANON, NH 03766

WWW.UPNE.COM

NIGHTBOAT BOOKS

NEW YORK

WWW.NIGHTBOAT.ORG

"The wiggle of a worm as important as the assassination of a president."

AGNES MARTIN

It is said that silk filature began in China under a mulberry tree in a teacup resting lightly in the slender hand of the empress Hsi-ling shi. A brin unfurls from the frisson tangle. She reaches in, begins to reel filament from the soft envelope of the cocoon. That is how people like to tell it.

You know the Nigerian proverb—until the lions have their own historians, history will always be told by the hunters.

If you don't know it
why not

ITHOUGHT

YOUSHOULD

KNOW

HOWITIS

WITH

THE

CREATURES

WHOMADETHIS

OUR

SHORT

PRODUCTIVE

LIVES

HOWOUR

MOTHER

BOMBYX

MORI

BOMB

FORSHORT

APUPA

INSIDEHER

SILK

COCOON

AFTER

EIGHTEEN

DAYS

CRACKS

4

INTO
HERNEXT

LIFE
ASAMOTH

HERSKIN

SPLITS

ATTHENOSE

CROWDSBACK

OFFHER

BODY

FOUR

WINGS

OFTHEFUTURE

FOLDED

ACROSS

HERCHEST

ANDWITHTHEM

SIXLEGS

TWOFEELERS

SOPHISTICATED

HORMONALNERVOUS

ANDRESPIRATORYSYSTEMS

AMULTICHAMBERED

HEART

SHEWANTSJUST
TWOTHINGS

TOGETOUTOFTHERE
ANDTOHAVESEX

SOSHE

SPITS

ANDSHOVES

HERWAYOUT

ABATTERING

RAMBREAKING

THREADSWITHTHETENSILE

STRENGTHOFSTEEL

ANDREMARKABLE

ELASTICITY

FREETODRYHEREXPANDING

WINGSINAIR

INAMASSIVE

BURST

SHEBROADCASTSHER

PHEROMONES

APHRODISIACTO
MALES

SMALLANDVIGOROUS
LISTENINGHARD

WITHOVERSIZED
FEATHERYANTENNAE

RIDICULOUSLYEAGER

THEYMAKETHEIRWAY

USINGCOMPOUNDEYES

KALEIDOSCOPIC

FROMKALOSBEAUTIFUL

ANDSKOPEINTOVIEW

SEEINGHER

EVERYWHERE

ANDBADLYWANTING

TOBESEEN

EVERYWHERE

BYHER

A TREMENDOUS
FLUTTERING ENSUES

SOAWING

ISATHING

THATGETSYOU

THERE

TOTHEBLISS
OFBEING

TAILTOTAIL
FORHOURS

FIVETHOUSAND
YEARS

MALEOR
FEMALE

ALLTHATFUSS
ABOUTNOTFLYING

IFWEMATE
WEAREALL

CALLED
QUEENS

A NEW

MOTHER

DOES NOTHING

HALFWAY

SHESWELLS

FLUFFYBELLIED

GREATWITHEGGS

THREETOFIVEHUNDRED

THESIZEOF

SESAMESEEDS

THEYSPILLFORTH

INTWOBATCHES

AFEWHOURS

RESTBETWEEN

STICKYANDGOLDEN

THEYLODGE

ALLOVERTHE

COCOON

HEALTHYEGGS

TURNFROM

YOLKGOLD

TOBLUISH

BLACK

INTENDAYS

INACOOL

DRY

PLACE

THEEGGS

CANGO

DORMANT

UPTO

TENMONTHS

TOBEREVIVED

INAPOUCHWARMED

BETWEENTHE

BREASTSOFAWOMAN

ORLETSBEHONEST

AHEATEDROOM

INIDEAL

CONDITIONS

THEEGGS

STARTINCUBATING

WHENTHEBUDS

ONTHEMULBERRY

ARETWO

CENTIMETERSLONG

SOITBEGINS

FIRSTINSTAR

MYOWNEGG

TREMBLES

STICKYSOFT

IEATAHOLE

THROUGH

ASMALLSPOT

ONITSSURFACE

THROUGHA

MICROPYLE

ON

ONE

END

IEMERGE
INMYFULLGLORY

UNIVOLTINE
WONDER

SILKWORM
OFTHEYEAR

INAGLITCHOF
NOMENCLATURE

IAMCALLEDAN
ANT

RESPLENDENT

INFINEBROWNFUZZ

AWRIGGLINGBIT

ANEIGHTH

OFAN

INCHLONG

AGLEAMINGBLACK
FACETHEMOON

WOULDLICKIFITCOULD
ILOOKGOOD

SOMETHING

DELICIOUS

HITSMYMOUTH

INSTINCTIVELYIOPEN

MULBERRYLEAF

NECTARFLOODSIT

ISAVOR
GOSLOW

IFEELIAM
CERTAINLYLOVED

SURROUNDEDBY

HUNDREDSOFSIBLINGS

NEWBORNSEATING

NEWBORNLEAVES

THECUT

EDGES

THE

TENDERPORTIONS

SOFTSUCCULENT

BETWEENTHEVEINS

CATERPILLARS

MUSTBEFED

LEAVESOF

THEIROWNAGE

WRITES

WILLIAMSTALLENGE

IN1609

REMUNERATED

BYTHEENGLISHCROWN

TODOSO

FUNNYTO

READTHIS

4609YEARS

AFTER

OURFIRST

NARROWFABRICS

WEREBURIEDIN

ZHEJIANGCHINA

BITSOFRIBBON

FRAGMENTSOFSILK

ALLDYED

RED

3375YEARSAFTER

THEFIRSTGHOSTS

PIECESOFSILK

IMPRINTEDON

BRONZEVESSELS

WERERECORDED

BUT

HEREWEARE

SENSITIVETO

AJAR

WHENTHEYCOME

TOCLEAN

WETURN

SIDEWAYSANDFREEZE

ARESWEPTGENTLYASIDE

ONTOFINENETSOR

PERFORATEDPAPER

RESTINGON

TRAYSOFCHESTNUT

ORBAMBOO

TORELISH
THEFRESH

SELVAGE
OFLEAVES

NARROWFABRICS

INDEED

LOOKATME

IHAVEBEEN

EATING

FORDAYS

NO LONGER

WEAK

I LIFT MY HEAD

AND

MIRACULOUS

THING

DEEPSLEEP

COMESSHINING

TRULYMIRACULOUSTHING

WAKINGUP

WESLIP

OURSKIN

ITISAFUNCTIONOFPOETRY

TOLOCATE

THOSEZONES

INSIDEUS

THATWOULDBE

FREE

ANDDECLARE

THEMSO

WRITESCD

WRIGHT

AREYOUSURPRISED

IQUOTEAPOET

DONTBE

WEINVENTEDLANGUAGE

INDIVINATIONS

ASEARLYAS

THESHANGDYNASTY

IN1050BC

YOULLFIND

ORACLESCRIPT

CHARACTERS
WRITTEN

ONTORTOISE
SHELLSFOR

SILKFABRICSAND
MULBERRYTREES

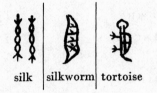

silk | silkworm | tortoise

EVERWONDEREDWHY

THEANCIENTORACLE

SCRIPTFROMCHINA

HASAWRITINGSTYLE

CALLEDBIRDAND

WORMSCRIPT

EVERCONSIDEREDWHY

BOOKONEOF

THECONFUCIAN

ANALECTS

ISCALLEDDIGESTED

CONVERSATIONS

NO

REALLY

FROMAPHILOSOPHER

BORNINA

CAVECALLEDTHE

HOLLOWMULBERRYTREE

I WILL RECITE

MY FAVORITE PASSAGE FOR YOU

WHENIHAVEPRESENTEDONECORNER

OFASUBJECTTOANYONEANDHE

CANNOTLEARNFROMITTHEOTHER

THREEIDONOTREPEATMYLESSON

MULBERRYTRANSLATESUS

WETRANSLATEIT

LOOKTHERADICALFORSILK

ISINTHEWORD

OK

EMBARRASSEDTOSAY

INMYGREATEXCITEMENT

IFELLASLEEP

HOWMANYHOURS
WASTHAT

IMSOHUNGRYI
SHUCKMYSKIN

ANDDEVOUR
ITWHOLE

MYNEWSKIN

ISGRAY

CRENELLATED

AND

FOURSIZES

TOOBIG

ITSMYTHIRD
INSTAR

THEREIS
THATWORDAGAIN

LATINOF

OBSCUREORIGIN

IPREFERTHESPANISH

INSTANCIA

TO

URGE

FIRSTILIKEDEDGES
NOWILIKEITALL

SMALLMARVELSOF
WHOLELEAFARCHITECTURE

ON A WAXING MOON

CUT THE LONG BRANCHES

ON A WANING MOON

THE SHORT

THUNDERSTORMS

WEREFUSETOEAT

WHENWEEAT

THESOUNDOF

TORRENTIALRAIN

PLAYINGONLEAVES

WECANTSTAND
STRONGSMELLS

LIKEIT
SWEETANDCLEAN

OURSHITWHISKEDAWAY

TOFEEDSHEEP

WESEEYOU

WESEEYOUDOINGTHEWORK

WEARE
OLIGOPHAGUS

MULBERRY
MONOGAMOUS

LEAF
POLYAMOROUS

MULBERRY

LEAVESNO

TWOALIKE

THEYCLEARHEAT

METABOLIZESUGAR

ANDEXPELWIND

WELOVETHEM

COOLEDINTHESHADE

INSATIABLE

VORACIOUS

IEATTOOMUCH

BUTITSJUSTSOGOOD

CHEW
SIDEWAYS

INTHOUSANDS
OFARCS

INDIZZYING
DETAIL

ENOUGHTOWRITE

THEGREATESTBOOK

ONMULBERRICULTURE

WHICHREMINDSME

ASILKMANUSCRIPT
FOUNDINATOMB

INMOUNTAINOUS
HUNANPROVINCE

ISTHEOLDEST
RECORD

OFABOOK
CALLED

THEICHING
易經

THEBOOKOF
CHANGES

LOOK

ATTHE

8TRIGRAMS

THE64HEXAGRAMS

YOUWILL

SEE

OURLEAVES
STREWNINLAYERS

WHOLEOR
EATENTHROUGH

WHENPUNCTURED
TASTEOFLIGHT

IWROTETHAT
THROUGHONE

THEWORDCHING
經

SIGNIFIESTHEWARP
THREADSOFATEXTILE

ITMEANSWHATISREGULAR
AREFERENCE

THEJAGGEDRADICAL
糸

FORSILK
PRECEDESIT

CONSIDERTHE

HEXAGRAMS

OFTHE

ICHING

1CREATIVEHEAVEN

2RECEPTIVEEARTH

3DIFFICULTY

ATTHEBEGINNING

IIMPLOREYOU

WHO

WOULDNEEDTOSAY

THESETHINGS

SILK

SI

TOSAYITINCHINESE

WITHTHEWRONGTONE

ISADEATHBY

STABBING

ISTHENUMBER

FOUR

ISLITERALLY

THIS

THERADICAL

INTHECHARACTERFOR

SILK

絲

PRECEDES

HUNDREDSOFWORDS

WORDSFORPAPER

紙

TEXTILE

紡織品

FORTHEVOLUMEOFABOOK

編

WORDSFORWARP
經

WEFT
緯線

LATITUDE
緯度

LONGITUDE
經度

PARALLEL
緯線

ROUTE
線路

WORDSLIKECOMPILE
编

COMPOSE
组成

EDIT
编辑

WEAVE
编织

ARRANGE
编排

WRITE
编写

MAKEUP
組成

FABRICATEINVENT
編造

FORMTEXTUREESTABLISHORGANIZE
組織

PLAITTRESS
編

SPIN
紡

NET
STRING

WIRE
THREAD

LINEORA
FILAMENT

SHAPEDLIKEALINE
線

THERADICAL

INTHECHARACTER

FORSILK

PRECEDESBODY

GROUPSETSERIESCORD

組

ABIDING

IMMANENT

ORDINATE

CHANGELESS

CONSTANT

經

REVOLUTIONARYREVOLUTIONIST
THEOLDESTCOLOR

RED
紅

GOONCARRYONCONTINUEPROCEED

繼續

MANAGESTANDPASSTHROUGHENDURE

經

ADEFORMATION

形變

ADEATH

命終

SILKENSLIGHTESTSMALLEST
TRIFLINGTHELEAST

SLIGHTLYHARDLY
ALITTLE

ABIT
絲

IREARUP
ICALMDOWN

AFAT
LETTERL

CRASHEDOUT
MIDAIR

IUSEDTOCALLIT
DIAPAUSE

NOWCALLIT
TRANS

MOVING

INMYOLDSKIN

INSIDEIT

MYNEWSKIN

FEELSCLEARANDSHINY

FEELSEVERYTHING

INMYFOURTH

INSTAR

IKNOWMYTRUESKIN

ISTRANSFORMATION

MEDIUMAND

MATERIAL

THEYSAY

IHAVEASHORTLIFEBUT

IHAVEANEVENSHORTER

DEATH

IHAVESOMANY

ITPAINSME

IMAGINETHIS

FORFIVETHOUSANDYEARS

DEATHCOMESORIT

COMESTHREEWEEKSLATER

ITSTHECOMINGBACK

THATSHARD

YOUTHINK

IAMMORBIDIAM

IMAGINETHELANGUAGE

WRITTENINME

MEMENTO
MORI

MORUSALBA
MULBERRY

BOMBYXMORI
ME

MULBERRYMULBERRY

MULBERRY

IMOVESLOWLY

STARTFROMTHESIDE

THEFINEHAIRS

AREASHIVER

THROWMYHEAD
BACK

ANDLAUGH
ANDINLAUGHING

TRANS
NEARLYTHIRTYHOURS

DIFFICULTTO
EXTRICATEMYSELF

THISTIME
THISSKIN

WHOCANGETME
OUTOFIT

ADRIENNERICHWRITES

LOVEISAPROCESS

DELICATEVIOLENT

OFTENTERRIFYING

APROCESSOF

REFINING

IKNOWSHE

MEANTUS

OUR NAME MEANS
TREASURED

SERICULTURE
IS A CULTURE OF

LOVE
I SAY IN IT

OFLIVING
ANDDYING

OFINTERDEPENDENCE
HONORABLERELATIONSHIPS

TENDINGANDEXPERTISE
OFRARECOMPATIBILITY

INTHEEXPANDING

UNIVERSEOFMYBODY

IHAVE28CHROMOSOMES

14623PREDICTEDGENES

4000MUSCLES

NOTTOBRAG

SIXSIMPLEEYES

TOMAKEOUTLIGHT

AROBUSTTHORAXANDABDOMEN

MYRETRACTABLEHEAD

MYPROLEGSMYTRUELEGS

MYCLASPERSINTHEREAR

DIDIMENTIONMYHORN

WHATITSFOR

PLEA
SURE

INSIDEME

SPIRACLES

CONCENTRICBRANCHES

AWEFT

TOOBEAUTIFUL

TOSEE

NABAKOVWRITES

YOUREADWITHYOURSPINE

IREADWITHMYBREATHING

ATRANSPARENTCHAINOFTUBES

NINEPAIRS

THEYFLOWER

ONEACHSIDEOFMYBODY

WITHEACHCONTRACTION

THEYCIRCULATE

DELICIOUSOXYGEN

INMOVEMENT
FRESHNESS

IAMFULLYFLEDGED

FATASAFINGER

PALESLATEBLUE

OYSTERWHITE

TENTHOUSANDTIMES

HEAVIER

THIRTYTIMES

LONGER

ABOUTTHIRTYDAYS
OLD

BUTWHOIS
COUNTING

ME
SILKWORMS

LOVE
TOCOUNT

ITCALMSMYNERVES

IGETRESTLESS

FIDGETY

STARTWANDERING

MYCHEST

GOESTRANSPARENT

ISHRINKALITTLE

PINKISH

THROW

MYHEADBACK

ANDFEEL

LIKE

IMGOING

TOTHROWUP

SILK

COMESSPUTTERINGOUT

JUSTBELOWMYMOUTH

MYSPINNERET

WORKS

NINEORTEN

INCHESINTHE

FIRSTMINUTE

SIXTYFIVEELLIPTICAL

MOTIONSMYHEADIS

SPINNING
THEBRIN

ISSUESIN
AGLUTINOUSSTATE

HARDENSINTOLINES
BECOMESSTRUCTURE

WITHSTRENGTHLENGTH
ANDLUSTER

THEFIBROINSTRANDS
EMERGEPRISMATIC

TWOTRIANGULARTUBES
GLUEDINSERICIN

WHENLIGHTSHINESTHROUGHAPRISM
ITBREAKSINTOSEVENCOLORS

ACONTINUOUSSPECTRUM
WITHINFINITEPOSSIBILITIES

WITHELASTICITYAFFINITY

ANDTHERIGHTMINDSET

ALLWAYS

AREEASY

ONCEISTARTWEAVING

ICANTHEAR

A PRACTICE

IS NOT A THING IN ITSELF

IT IS A WAY TO BE

HAPPY AND CALM IN LIFE

IWRITEIT
SIDETOSIDE

INFINITYLOOPS
FIGUREEIGHTSPINS

ASMUCHASSIXMILES
SIXTYHOURS

THREEDAYS
SUREICOUNT

IMODULATEIT

SLOWITDOWN

ELONGATETHELOOP

CONCENTRATEONTHELINE

ITRYNOTTOHAVEIDEAS

BECAUSETHEYREINACCURATE

INSTEADITRYTOTHINKOFTHEWORDS

IWANTTOSPENDTIMEWITH

BETASHEET

BOUSTROPHEDON

WEAVINGA

WEFTTHREAD

ANELEGIACCOUPLET
ANEPITAPH

CARVEDIN
ALTERNATINGDIRECTIONS

TOREVERSETHEREVERSE

BECOMESTHEWORK

TOSEPARATEYOURRIGHTBRAIN

FROMYOURLEFTANDBUILDBACKUP

TOREMOVESPECIFICOUTCOMESAND

TRULYCREATESOMETHING

NEW

EVENTHATWORDLOOKSOLD

SILK
LANGUAGE

MEDIUMS
INFINITELYLARGER

THAN
ANYINTENTION

THISLITTLE
SILKINME

POLYMATH

STRINGFIGURE

PRESENT

SMALLWILD

THINGSTHATSHINE

OBSTINATELY

HOLDTHEBODY

FREEFROMHARM

CLOTHTISSUE

BODYISSUE

HERE

ISTHISTHING

IMADEOFMYSELF

WITHOTHERS

ALIVE

INYOU

IGIVEYOUMY

繭

THISFLYINGGARMENT

FORTHESOUL

IVEDRAWN
INFINITY

INTO
IT

RESEARCH SAMPLER

The earliest human function of silk fabrics was wrapping children's bodies in the tomb. Inventory: a bundle of bright silk yarn thirty feet long in her hand. A billion-foot-long silk yarn for climbing to heaven.

•

In Madagascar during the Malagasy ritual of *famadihana*, ancestors' bones are exhumed from family crypts, celebrated with feasts and libations, dancing, and live music; they are offered prayers, blessings and consulted for guidance. Afterwards, their bodies are rewrapped singly or together in an ancestor bundle in freshly woven wild silk, and restored to the family crypt until the next celebration.

•

Ancient Chinese writings on silk were to com-
municate not only among humans, but between
human and spiritual beings. Silk letters were tied to
the foot of a wild goose. An ancient Chinese poem
says, "calling to the boy to cook the carp, in its body
a silk letter of one foot."

•

An excerpt from an ancient letter "protected by an
inner wrapper of brown silk and an outer envelope
of coarse fabric which bears instructions for the
delivery of the letter" from a series found in a post-
bag in Dunhuang, China written in Sogdian, an
Iranian language spoken in present day Uzbekistan:
"Dear Sirs, It would be a good day for him who
might see you happy and free from illness; and sirs,
when I think of your good health, I consider *myself*
immortal!"

•

A "book" of silk is a measure forty feet long, annotated on the selvage of ancient cloth. Other measures of silk include ells and aunes, mommies and piculs.

•

"I have often taken my little three inch brush prepared writing silk four feet in length, and gone off to inquire of different dialects," from a Chinese philosopher's letter in the first century.

•

In the second century, the Chinese Empress Teng, a lover of literature, asked only for chih, a paper made of waste silk, and ink cakes as royal gifts.

•

In the fourth century, the Chinese poet Su Hui wrote a reversible poem in five colors of silk, designed to correspond to a star gauge for reading the cosmos. Her poem had nearly eight thousand possible readings. Su Hui sent this poem as a letter to her husband who was far away. Upon reading Su Hui's poem, the couple reunited for life.

•

Throughout the Muslim world there is a strong belief in the protective power of the written word in the Koran. Between the eighth and the twelfth century, single, horizon-like inscriptions were written on tiraz (from *tarz*, Persian for embroidery), in Arabic letters embroidered in silk on a linen or cotton ground. The writing honored the prophet Mohammed, named the commissioning

caliphate, said where and when the cloth was woven, and blessed and protected the recipient of the cloth. Sometimes a stray blessing from the weaver was appended.

·

In the Koran, paradise is conceived as a place of silken cushions and carpets. The prophet Mohammed is said to have remarked that he who wears silk in this life shall forgo it in the next. Mulham, with a silk warp and a cotton weft, was sometimes permitted, as only the cotton touched the body.

·

Bolts of Byzantine silk were held up as barriers for the crowd or unfurled as ground covering for a royal return. One kissed the hem of the Sultan's robe.

·

Heavily embroidered West African riga or robes of honor, magical and protective, especially in times of war, create an effect of bigness. "The older the silk embroideries get the shinier they will become. Your gown will tear while the embroidery remains intact."

•

"I am dying by inches from lack of any body to talk to about worms." Mary Ruefle's paraphrase of correspondence from Charles Darwin to William Darwin Fox.

•

Vladimir Nabokov, in his novel *Transparent*: "the spine is the true reader's main organ." In a private letter to Archibald MacLeish, he writes: "there is that movement of light in one of your most famous

poems that invariably sends a shiver of delight up and down my spine whenever I think of it."

•

Emily Dickinson's letter to Susan Dickinson, manuscript A637. "Tis a dange / rous moment / for any one / when the meaning / goes out of things / and Life stands / Straight — and / punctual X and / yet no contents / signal / comes / Yet such mo / ments are / If we survive / them they expand / us, if we do / not, but that / is Death X, whose / if is Everlasting / when I was a / little girl I called / the Cemetery / Tarrytown / but now I call it Trans — / A wherefore / but no more / And X the if / of Diety — Avalanche / or Avenue — Every / Heart asks which" Note: the X's are variant strains or alternate reading paths in the poem draft. "Contents" or "signal" are variant, as

is the phrasing that begins with "whose if is Everlast-
ing" and "the if of Diety."

•

Agnes Martin: I try not to have ideas because they're
inaccurate

•

Dianna Frid: I try to think of the words I want to
spend time with

•

Cecilia Vicuña: To reverse the reverse becomes
the work

•

Marta Werner: It is so hard to let go of contextual-
ization

•

Fiorenzo Omenetto: separate your right brain from your left, and build back up

•

Rosmarie Waldrop: language, a medium infinitely larger than any intention

•

Franck André Jamme's translation of a tantra painting: small wild / things that shine /obstinately

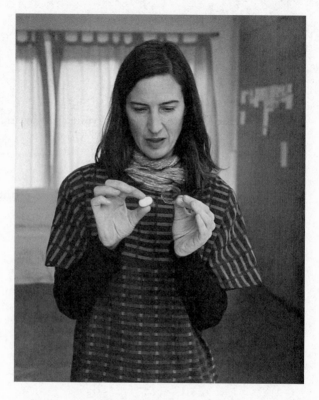

Jen Bervin holding a silk cocoon and a silk film
from Tufts at Montalvo Art Center, 2016.
Photo by Charlotte Lagarde.

PROJECT NOTE

Silk, as a material, is compatible with body tissues;
our immune system accepts it on surfaces as sensi-
tive as the human brain.

In 2010, I visited Tufts University's Bioengi-
neering Department, where David Kaplan and
Fiorenzo Omenetto were reinventing silk as a
cutting-edge technological material in a new form:
reverse-engineered liquefied silk. One facet of
their remarkable research captured my attention:
a silk biosensor in development, written nanoscale
on clear silk film. It was designed to be implanted
in the body to sense shifts in target materials—
blood sugar in hemoglobin, for example. The
meaningful health context, the scale of the writing,
and the simplicity of the material astounded me.

This type of film, due to its optical nature, can be read as a projection with fiber optic light. When I projected the test film in Fio's office, the clip art on the prototype I saw there gave me pause—the content gap really surprised me. I thought, if it is possible to write in that context—inside the body, on silk, at that scale, I wanted to think further about what else might be inscribed there.

I empathized with the sensor's future "reader," and imagined people with the sensor inside of them, in the anxiety-provoking space of monitoring it for abnormal changes in their health. I wanted to create something akin to a talisman, a powerful text hidden on the body to protect the wearer.

The poem is essentially a love poem. As I wrote it from the perspective of a silkworm, I often

thought of a quote I read by a Japanese weaver:
My clothes are my body, I do not loan them out.
If I give them, I give them for good.

As an artist and writer, I often take a research-driven approach to create interdisciplinary works that combine text and textiles. When most people think of textiles, they think of clothes. But textiles can cross boundaries: my first weaving teacher created woven designs for heart valves. Silk has a rich 5,000 year-old international cultural history. In thinking about what might be meaningfully written on a silk sensor inside the body, I became interested in which aspects of silk's history a sensor might encode and why.

My journey to create *Silk Poems* spanned six years, and developed with help and expertise from thirty international textile archives, medical libraries,

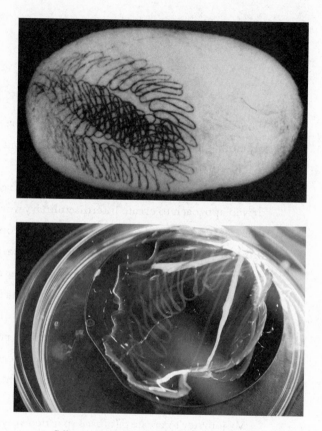

TOP: Silkworm patterned filament in the cocoon,
Japan 2016. BOTTOM: Fabrication view of *Silk Poems*
at Tufts University, version four, nanoimprinted
gold spatter on a 3.5 inch silk film, 2016.

Silk Poem strand suspended in silk film, microscopic view of gold letters. Photo by Bradley Napier.

nanotechnology and biomedical labs, and sericulture sites in North America, Europe, the Middle East, and Asia, thanks to a major grant from Creative Capital for this project.

The form of the poem strand is modeled on silk at the DNA level—the six-character repeat in the genome is the basis for the six letter enjambed line of the strand; the shape of the strand reflects both the filament pattern silkworms enact when writing

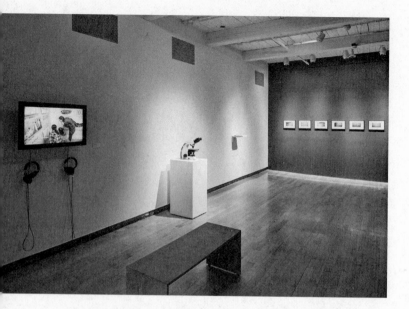

Installation view, *Explode Every Day: An Inquiry into the Phenomena of Wonder*, MASS MoCA, North Adams, Massachusetts, 2016. Photo by Tony Luong.

their cocoon, and silk's beta sheet, which forms like the weft thread in a weaving.

In 2016, at Tufts University's Department of Biomedical Engineering, we were able to fabricate the poem I wrote on silk film, thanks to the generosity of Fiorenzo Omenetto and the patience of Bradley Napier through the various trials. They used a mask to etch the poem in gold spatter on a wafer and poured liquid silk over it. When the silk dried, the letters were suspended in the film.

Silk Poems premiered in the year-long exhibition *Explode Every Day: An Inquiry into the Phenomena of Wonder,* curated by Denise Markonish and Sean Foley at MASS MoCA, from May 2016 to March 2017. In it, the poem in silk film was viewed through a microscope, accompanied by a video about the research process by Charlotte Lagarde, and a reading version of *Silk Poems.*

In the margin of this book, a tiny version of the poem strand accrues progressively, apace with reading. Bob Brown's *Words* (1931) was the first place I saw something like this, and I still marvel at how his poems disappear in plain sight, even when you're looking for them.

JEN BERVIN

ACKNOWLEDGMENTS

Thank you to the outstanding staff, grantees, and supporters of Creative Capital, past and present, for nourishing this work. *Silk Poems* received major support from a 2013 Creative Capital Grant in Literature, and additional in-kind support from Bogliasco Foundation, MASS MoCA, The Josef and Anni Albers Foundation, Brown University Literary Arts, Montalvo Art Center's Lucas Artist Program, Elizabeth Willis, The Camargo Foundation, and the Robert Rauschenberg Foundation.

Special and huge thanks to Fiorenzo Omenetto and David Kaplan at the Tufts University Bioengineering Department's Silk Lab, and to Amanda Schaffer, for your vast agile minds, and for inspiring and welcoming this work.

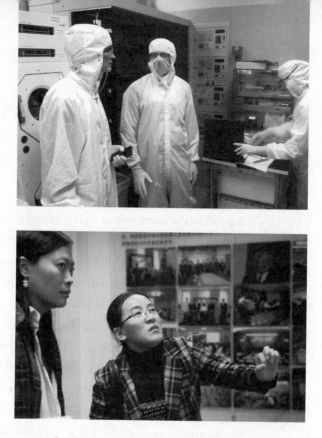

TOP: Jen Bervin and Ed Myers, Stanford University
Nanofabrication Facility, Palo Alto, California, 2012.
BOTTOM: Huang Haisu and Dr. Tieling Xing,
Soochow University Silk Engineering Department,
Suzhou, China, 2013.

Thank you, Charlotte Lagarde, for traveling the world with me to document this project, and for your remarkable gifts as a filmmaker, artist, and storyteller. Thanks for your support on all fronts. Your love, strength, companionship, humor and guidance sustain and inspire me.

Thank you Vamsi Yadavalli at Virginia Commonwealth University's Department of Chemical and Life Science Engineering, for experimenting with new trials of *Silk Poems* using a silk fibroin photolith technique in trials as small as the thumbnails in this book.

My gratitude for your expertise on the research trail to: Stanford University Nanofabrication Facility; Eva Labson, Assistant Manager, Antonio Ratti Textile Center, The Metropolitan Museum of Art; Karla Nielsen, Curator of Literature, Columbia

University Rare Books and Manuscript Library; Columbia University Starr East Asian Library; Fashion Institute of Technology Library; The Mütter Museum and Historical Medical Library; Stan Gorski, Special Collections Librarian, Gutman Library, and Marcella Milio, Curator, Paley Design Center, Philadelphia University; Nancy Kuhl, Curator, Beinecke Rare Books and Manuscript Library, Yale University, New Haven; Carol Bier, The Textile Museum, Washington D.C.; Musée des Tissus et Arts Décoratifs de Lyon, France; Maison des Canuts, Lyon; Institut du Monde Arabe, Paris; Bibliothèque des Arts Décoratifs, Paris; Silk Haku-butsukan, Yokohama, Japan; Japanese translation: Miwako Ozawa; Tokyo National Museum; Kyoto Municipal Museum of Traditional Crafts; Ori-nasu-Kan Museum, Kyoto; Nishijin Textile Cen-

ter, Kyoto; Metersbonwe Museum, Shanghai, China; Chinese translation: Huang Haisu; Dr. Tieling Xing, Soochow University Silk Engineering Department, Suzhou; Suzhou Silk Museum; Suzhou Embroidery Research Institute; The China National Silk Museum, Hangzhou; Qiaoxian Yu, Jiangang Yu, Yuhui Mei, and Tongyao Yu, Silkworm Farm, Tongxiang, China; The International Dunhuang Project, Dunhuang, China; The Liguria Study Center, Bogliasco, Italy; Francina Chiara, La Fondazione Antonio Ratti Textile Museum and Library, Como; Museo Didattico della Seta, Como; Frederica Centulani, Palazzo Mocenigo Library, Venice; Biblioteca Statale di Lucca; Topkapi Saray Muzesi Archive, Istanbul, Turkey; and Chuka Kuprava, State Silk Museum, Tbilisi, Georgia.

Thank you for your help and generosity:

Kenny Fries, Sawako Nakayasu, Jonathan Way, Xu Xi, Miho Kinnas, Jen Hyde, David Perry, Monika Lin, Arthur Solway, Violet Feng, Wang Mingjie, Laura Harrison, Mei-Yin Ng, Lydia Matthews, and Ayşe Aydoğan. For studio research assistance, deep thanks to Claudia Markey and Lauren Woodard.

I am grateful to the poet Yolanda Arroyo Pizarro for teaching me the Nigerian proverb in San Juan, Puerto Rico; to Allie Foradas, curator at MASS MoCA for introducing me to the Nabokov quote; and to Bibiche Lagarde for recounting counting; to the writers C.D. Wright, Cecilia Vicuña, Marta Werner, Rosmarie Waldrop, Franck André Jamme, and Tsuen-Hsuin Tsien. Tsien's book, *Written on Bamboo and Silk* (University of Chicago) is the source of the oracle script on page 53, and is quoted throughout the book. Though rooted in research

and intertextuality, *Silk Poems* is also invented, playful and speculative.

Deeply talented people designed this work and are to be roundly thanked. The poem strand and manuscript draft for the show at MASS MoCA was typeset by Heather Watkins. Paul Jordan of Bark Frameworks fine-tuned the microscope to hold the poem in the exhibition. Jeff Clark empathetically translated the manuscript into book form. Lindsey Boldt fielded all aspects of this manuscript expertly at Nightboat Books. I'm indebted to Stephen Motika, for the great work you do at Nightboat, Poets House, and on the page, and for championing my work as an artist and teacher for over a decade. It's a joy to join the many authors I admire in the Nightboat Books family.

Thank you Jody Gladding for the close feedback

and essential dialogue on the poem. For sustaining conversations, guidance, and support, thank you Dianna Frid, Mary Ruefle, Denise Markonish, Karen Emmerich, Elizabeth Willis, Cole Swensen, Nancy Kuhl, Helen Mirra, Joanna Howard, Catherine McRae, Elizabeth Zuba, and Francesca Capone.

Thank you to friends and publishers Anna Moschovakis and Matvei Yankelevich of Ugly Duckling Presse, Steve Clay of Granary Books, Christine Burgin and New Directions for your longstanding support.

Thank you to the professors, journalists, curators, institutions, and conferences for your support of this work and to transformative readers, audiences, and communities: past, present and future.

FURTHER READING

Douny, Laurence. "Silk-embroidered garments as transformative processes: Layering, inscribing and displaying Hausa material identities." *Journal of Material Culture* 16 (2011): 401–415. (Referenced on p. 160.)

Feltwell, John. *The Story of Silk.* New York: St. Martins Press, 1991. (Referenced on pp. vii, 25, 37.)

Kusimba, Chapurukha Makokha. *Unwrapping the Textile Traditions of Madagascar.* Los Angeles: UCLA Fowler Museum of Cultural History Textile Series, 2005. (Referenced on p. 155.)

Tsien, Tsuen-hsuin. *Written on Bamboo and Silk: The Beginnings of Chinese Books and Inscriptions.* Chicago: University of Chicago Press, 1962. (Image credit p. 53; referenced on pp. 51–53, 156–157.)

Xinru, Liu. *Silk and Religion. An Exploration of Material Life and the Thought of People A.D. 600–1200.* Delhi: Oxford University Press, 1998. (Referenced on pp. 158–159.)